Drawing *Florals* in 5 Easy Steps

Create Flowers, Leaves, and Elegant Shapes One Step at a Time

Marty Woods

ISBN 978-1-4972-0566-6

© 2022 by Marty Woods and New Design Originals Corporation, *www.d-originals.com*, an imprint of Fox Chapel Publishing, 800-457-9112, 903 Square Street, Mount Joy, PA 17552.

Library of Congress Control Number: 2021943313

We are always looking for talented authors. To submit an idea, please send a brief inquiry to acquisitions@foxchapelpublishing.com.

Printed in China
First printing

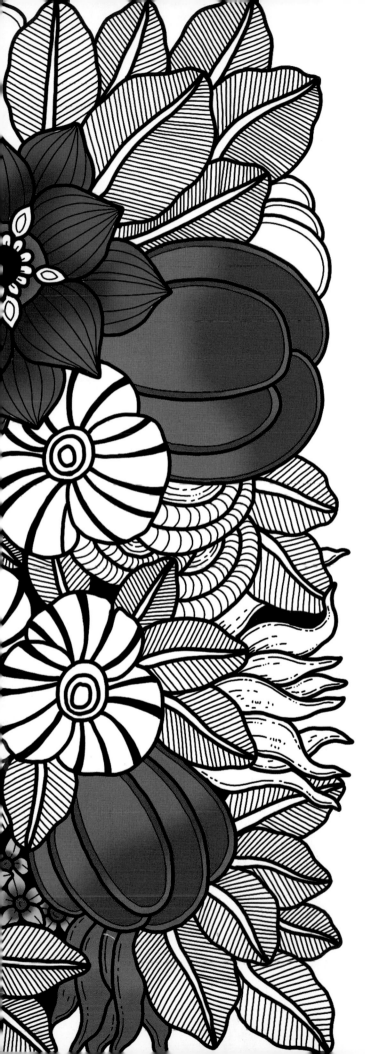

Contents

Introduction

I'm so glad you've decided to step inside this instructional book for doodling flowers. In these pages, I will show you how to draw 100 flowers, 21 leaves, and 10 doodle elements in a step-by-step method, teaching you how to create eye-catching motifs that wow as well as how to combine them once you've mastered the individual elements.

I have collaborated with so many companies, from Starbucks to TikTok, Pandora to the WWF, and I can't tell you how many people have asked me along the way how I create my nature-inspired designs. For me, and soon for you, it's simple: I start with one basic flower motif and build from there. In the pages of this book, I take you through my process, and as you follow the simple four- or five-step visuals, you'll find your own artwork blossoming before your eyes. In addition, I've included information on drawing tools and papers, so you can gather everything you need for drawing success.

Floral art is very flexible and without limit—you can use it in so many creative ways. You can turn motifs into beautiful, framed art to decorate, cheerful floral wall murals, inspiring floral-decorated journals, floral-themed coloring books, digital stamps or brushes, or even spectacular products or merchandise. Whether you're an aspiring artist or you just like to dabble, the possibilities are endless! You just need creativity and a wild imagination.

I hope you enjoy this book and perhaps start your own happy obsession with art!

Marty

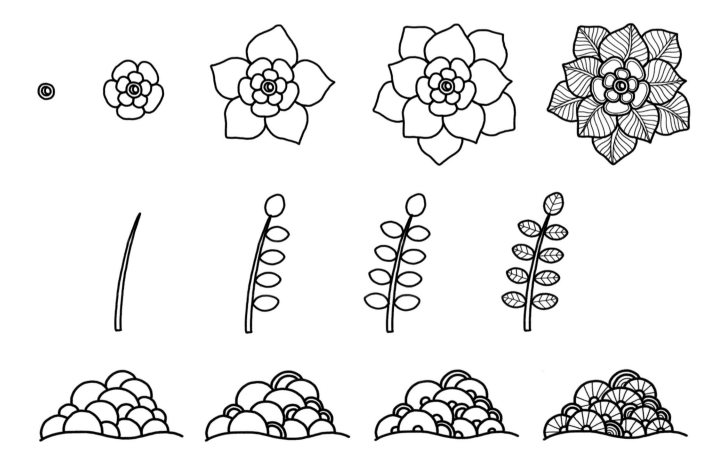

How to Use This Book

This book is for everyone. It does not matter if you are a beginner or already an amazing artist, you can join me and learn how to draw easy floral art, too. Ultimately, my objective is for you to be able to use your creativity and imagination to draw your own unique flowers and plants.

I use two different pens to draw and to give contrast, texture, and definition. I use size 1.0 for outlines and 0.1 for detailing. Other sizes are also acceptable as long as you can see the difference between outlines and detailing.

Each flower takes only five easy steps to draw. Steps 1 to 4 are to get the main outline and basic shape, while step 5 is where you get creative with putting in all the details. The sixth drawing is a variation, for ideas on how you can create two different looks from the same flower.

The leaves and doodle elements are even simpler than the flowers. They only require four steps to draw, and the fifth drawing is a variation on the idea to give them different looks.

If you are more into digital media, you can also use your phone, tablet, iPad, or computer to draw. You can use whatever drawing tools or media you are comfortable with that are available to you.

Get creative and do not be afraid to use your imagination!

Tools

Drawing Pens

Common drawing pens come in different size tips, ranging from the standard 0.05 to 1.0. The smaller tips (with smaller numbers) are suitable for delicate and more intricate detailing, while the bigger tips are good for outlines or filling in areas with ink. I usually just use black color pens, but some pens also come in different colors. Some brands have a wider range for their pen size tips, giving you more options. I recommend using good drawing pens such as Faber-Castell Ecco Pigments, Artline Drawing Systems, Sakura Pigma Micron®, Copic Multiliner, or Uni Pin. Good quality pens have better ink, do not bleed, do not fade easily, and are waterproof as well.

However, use any pens you are comfortable with; it is not a necessity to use specific drawing pens to draw. Markers, brush pens, gel pens, dip pens, ballpoint pens, calligraphy pens—these can all be used for drawing, too!

Paper

You can use any paper you like, but make sure the paper is suitable for use with your drawing pens. Some papers cannot handle pens like markers or brush pens. These pens might bleed into the paper and ruin your work. I personally love papers from Grandluxe sketchbooks, Daler-Rowney, and Fabriano, but any reasonably thick paper is great for drawing. Experimenting with various papers is a great way to find out which one works best for you and your media. I suggest getting a good sketchbook to start drawing and practicing.

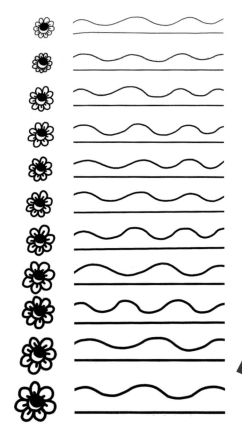

A variety of pens can be used for floral art to show contrast between your outlines and your details.

The size and appearance of your lines and floral elements will change based on the thickness of your pen tip.

Experiment with different types of paper to find out what you like best.

A good sketchbook is the best place to get started learning floral art. It's portable and easy to use.

Drawing Tips

1. **Use pencil.** Feel free to use pencil first if you are not ready to draw directly with pen. Do not ever feel intimidated when you see people drawing directly using a pen. Using pencil first to sketch is just a process in learning and can alleviate the pressure to not make mistakes—if you do make a mistake, you can simply erase and try again.

2. **Don't strive for perfection.** You do not have to draw everything perfect with perfect lines, perfect shapes, or perfect symmetry. It is okay to have uneven lines, different sizes of petals, disconnected lines, or even an extra dot. In my case, doing floral drawing, I always believe nature is perfect in its imperfect way—too-perfect lines will look artificial rather than organic!

3. **Practice free-hand drawing.** This is to make you more confident and more comfortable with your art. Try practicing drawing without overthinking what to draw or where to put your elements. Let your creativity flow on the paper. Be brave. Over time, drawing what you love will come naturally to you.

4. **Keep a sketchbook.** I recommend always having a small and handy sketchbook around; an A5 size (5¾" x 8¼") sketchbook is just perfect. I always have my sketchbook everywhere I go. Try to draw whenever you have time to spare and make a goal to fill every page in the book. It does not have to be perfect, beautiful, or complicated; even simple drawings or sketches will do. When all the pages are filled in and completed, it is time to look back— you will be surprised to see how much progress you have made in your journey.

5. **Embrace mistakes.** We make mistakes all the time when we draw. It is a part of the learning process. Do not get stressed over little mistakes. If you make some little mistakes, whenever possible, cover your mistakes or just improvise your work. Most of the time, only you as the artist know about the mistake.

6. **Get creative and do not be afraid to be weird.** Never be bound by the rules. How can you change this to that? What if you put circles instead of straight lines? Where can you use these squiggles? How about a rose with tendrils? What if you create a new, imaginary flower? Have you ever seen alien-looking leaves? Don't be limited by reality!

Make a goal to fill every page in your sketchbook and you'll get plenty of practice.

Patterns and Lines

Before we start, I want to talk about patterns and lines. You will be seeing and using them a lot in this book, so it is good to know about them. I use them mainly at the final step to add the finishing details to each flower, leaf, or doodle element.

Patterns

I love patterns! Patterns can elevate your drawing from plain to eye-catching and elaborate. Even simple patterns can add interest to your drawing and make a huge difference to your finished work. You can use any patterns you like, but here are some simple, easy, and effective patterns you can use to decorate your floral drawing. Refer back to this page if you are running dry on inspiration later!

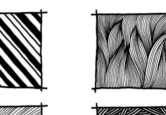

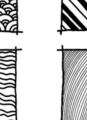

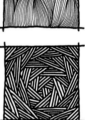

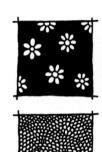

Lines

Lines are magic in drawings. They can elevate and accentuate your work. When you draw, you will be using many different styles of lines. Some are straight, some curvy, some wavy, and some squiggly. You will be using thick and thin lines, too. Just remember that you do not have to make them perfect all the time. Here are some of the basic lines you should practice. Over time, even drawing a straight line will come naturally for you.

Flowers
Step by Step

How to draw Rose

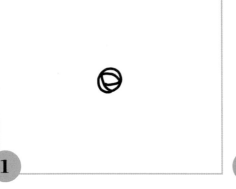

1

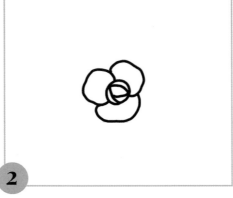

2

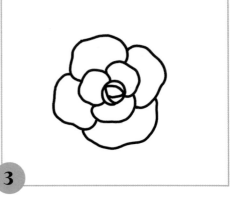

3

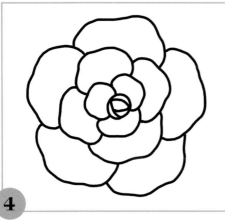

4

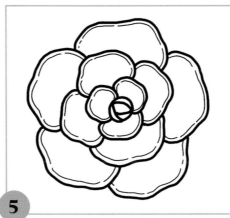

5

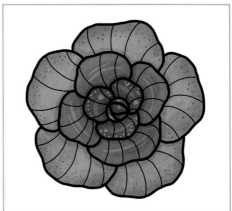

Colored Variation

How to draw Poinsettia

1

2

3

4

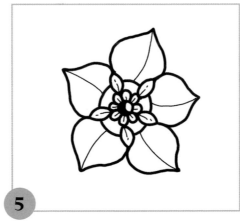

5

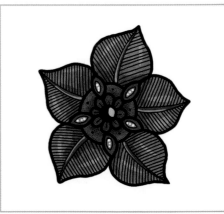

Colored Variation

How to draw St. Bernard's Lily

1

2

3

4

5

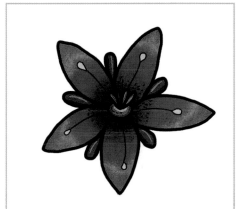

Colored Variation

How to draw Poppy

1

2

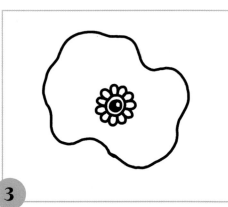

3

4

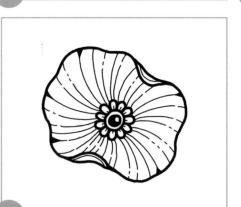

5

Colored Variation

How to draw Hibiscus

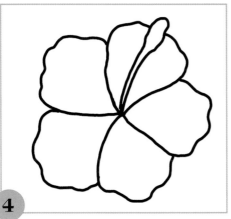

1

2

3

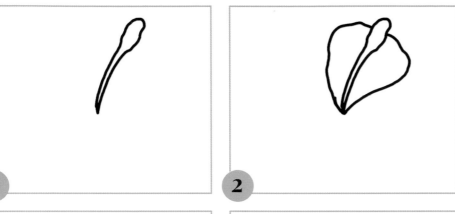

4

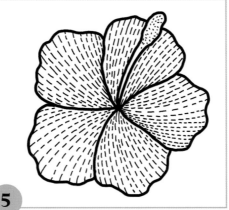

5

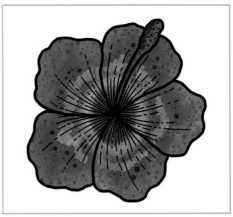

Colored Variation

How to draw Bubble Flower

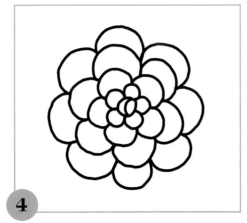

1

2

3

4

5

Colored Variation

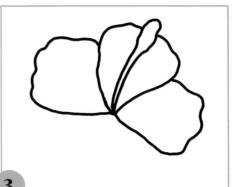

How to draw Buttercup

1

2

3

4

5

Colored Variation

How to draw Phlox

1

2

3

4

5

Colored Variation

How to draw Allium

1

2

3

4

5

Colored Variation

How to draw Rafflesia

1

2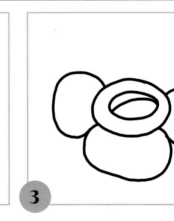

3

4

5

Colored Variation

How to draw Windmill Flower

1

2

3

4

5

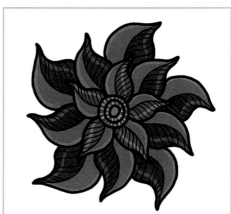

Colored Variation

How to draw Anemone

1

2

3

4

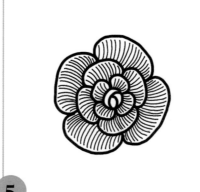

5

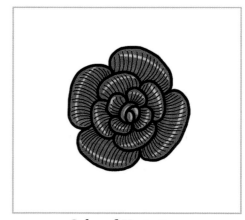

Colored Variation

How to draw Azalea

1

2

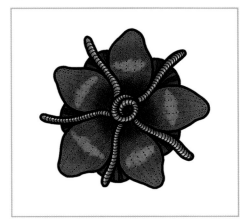

3

4

5

Colored Variation

How to draw Forget-Me-Not

1

2

3

4

5

Colored Variation

How to draw Dahlia

1

2

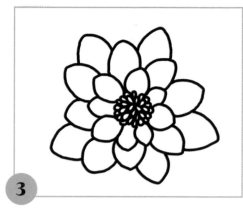

3

4

5

Colored Variation

How to draw Lilypad Bloom

1

2

3

4

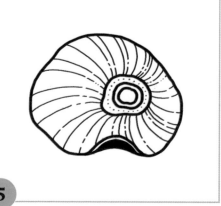

5

Colored Variation

How to draw Marigold

1

2

3

4

5

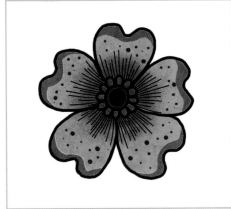

Colored Variation

How to draw Morning Glory

1

2

3

4

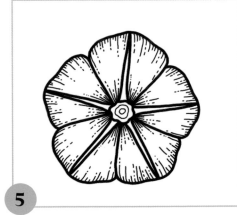

5

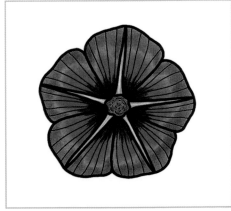

Colored Variation

How to draw Rock Cress

1

2

3

4

5

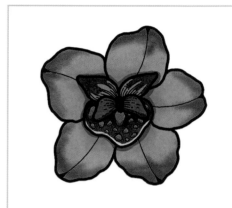

Colored Variation

How to draw Cosmos

1

2

3

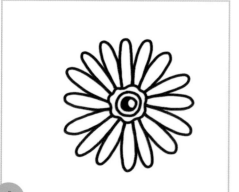

4

5

Colored Variation

How to draw Lobelia

1

2

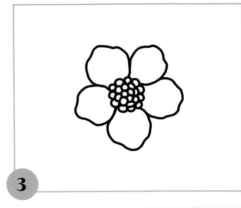

3

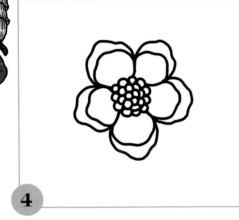

4

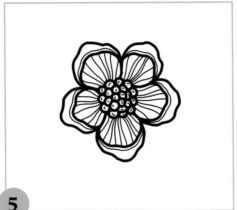

5

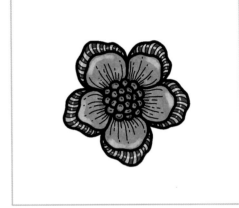

Colored Variation

How to draw Layered Flower

1

2

3

4

5

Colored Variation

How to draw Mum

1

2

3

4

5

Colored Variation

How to draw Daffodil

1

2

3

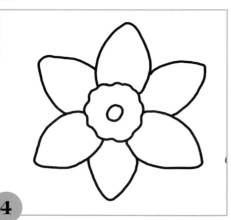

4

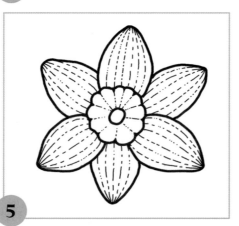

5

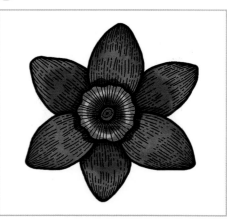

Colored Variation

How to draw Frilled Lily

1

2

3

4

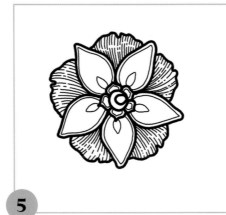

5

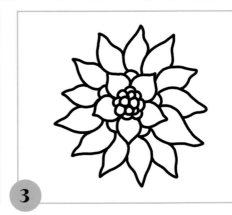

Colored Variation

How to draw Windblown Flower

1

2

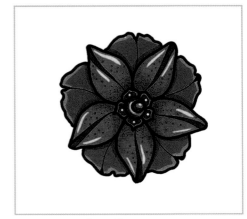

3

4

5

Colored Variation

22 Drawing Florals in 5 Easy Steps

How to draw Begonia

1

2

3

4

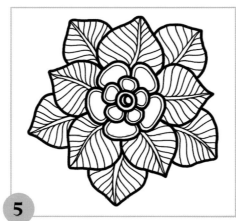

5

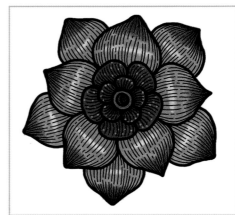

Colored Variation

How to draw Peony

1

2

3

4

5

Colored Variation

How to draw Passion Flower

1

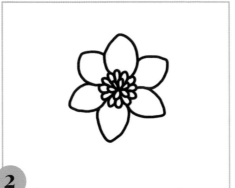

2

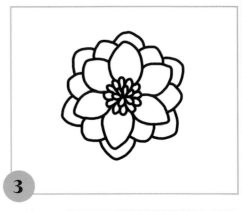

3

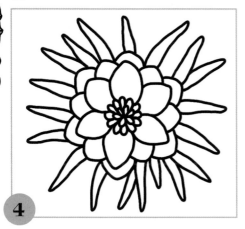

4

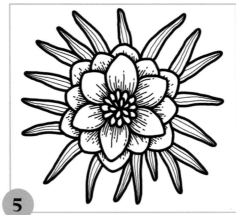

5

Colored Variation

How to draw Camellia

1

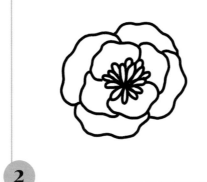

2

3

4

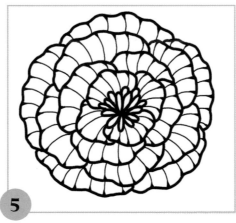

5

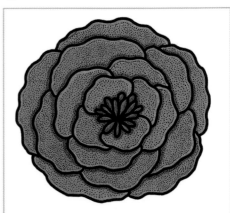

Colored Variation

How to draw Alyssum

1

2

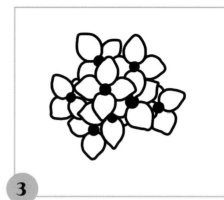

3

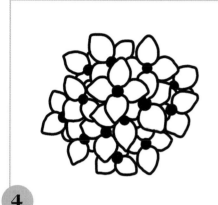

4

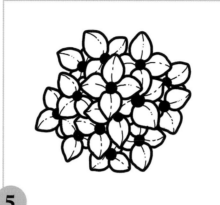

5

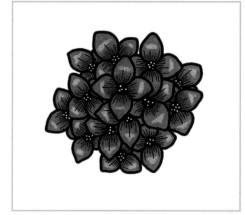

Colored Variation

How to draw Curvy Flower

1

2

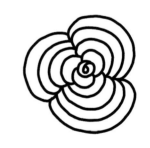

3

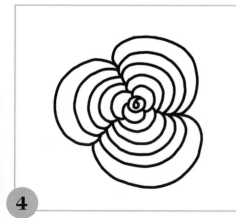

4

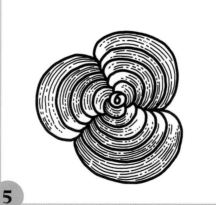

5

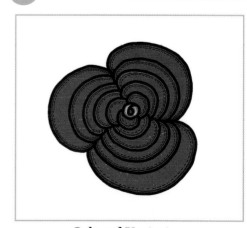

Colored Variation

How to draw Moonflower

1

2

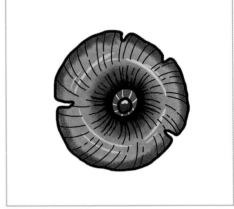

3

4

5

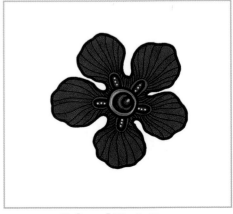

Colored Variation

How to draw Cherry Blossom

1

2

3

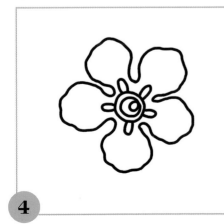

4

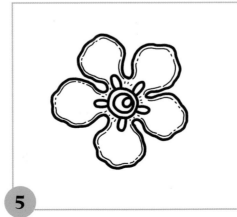

5

Colored Variation

How to draw Dogwood Bloom

1

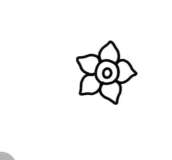

2

3

4

5

Colored Variation

How to draw Spring Beauty

1

2

3

4

5

Colored Variation

How to draw Wallflower

1

2

3

4

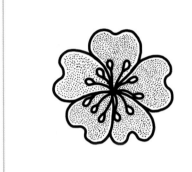
5

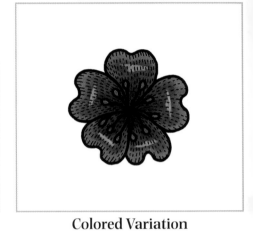

Colored Variation

How to draw Aster

1

2

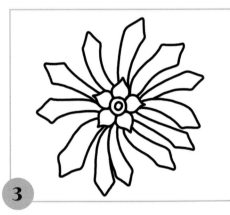
3

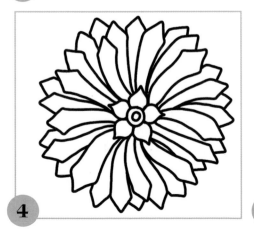
4

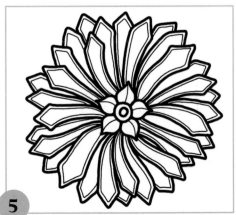
5

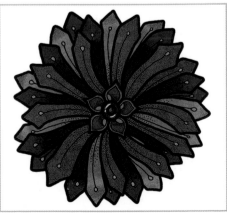

Colored Variation

How to draw Jasmine

1

2

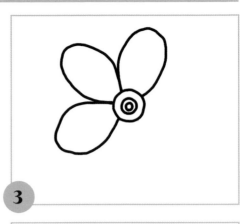

3

4

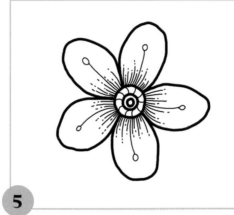

5

Colored Variation

How to draw Orchid

1

2

3

4

5

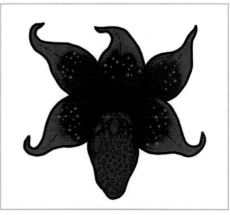

Colored Variation

How to draw Plumeria

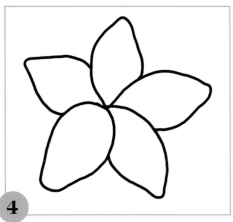

1

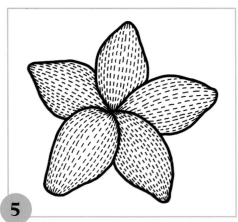

2

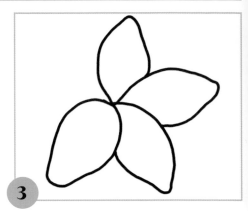

3

4

5

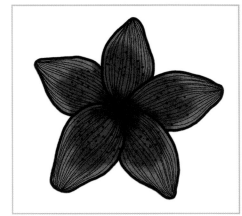

Colored Variation

How to draw Weigela

1

2

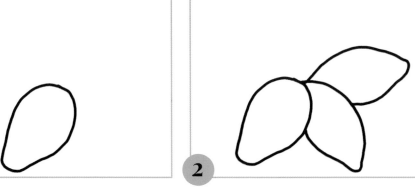

3

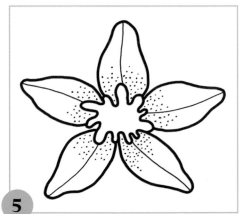

4

5

Colored Variation

30 Drawing Florals in 5 Easy Steps

How to draw Gerbera

1

2

3

4

5

Colored Variation

How to draw Lilac

1

2

3

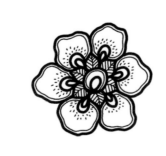

4

5

Colored Variation

How to draw Round Flower

1

2

3

4

5

Colored Variation

How to draw Chrysanthemum

1

2

3

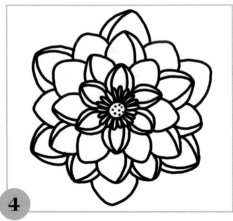

4

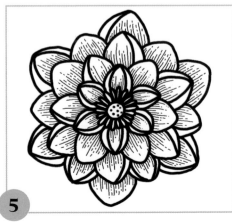

5

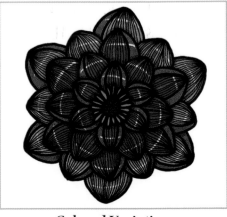

Colored Variation

How to draw Baby's Breath

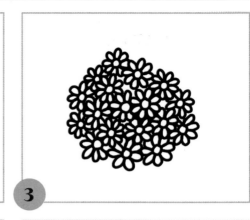

1

2

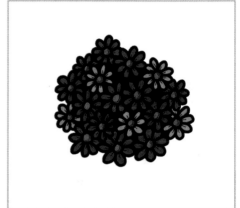
3

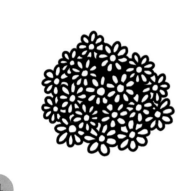
4

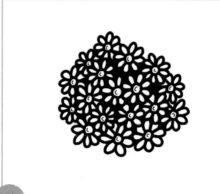
5

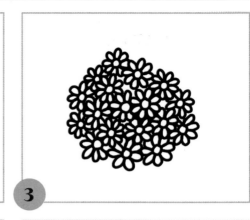
Colored Variation

How to draw Heart Spiral Flower

1

2

3

4

5

Colored Variation

How to draw Cone Flower

1

2

3

4

5

Colored Variation

How to draw African Daisy

1

2

3

4

5

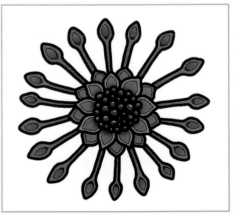

Colored Variation

How to draw Heartburst Flower

1

2

3

4

5

Colored Variation

How to draw Dawn Flower

1

2

3

4

5

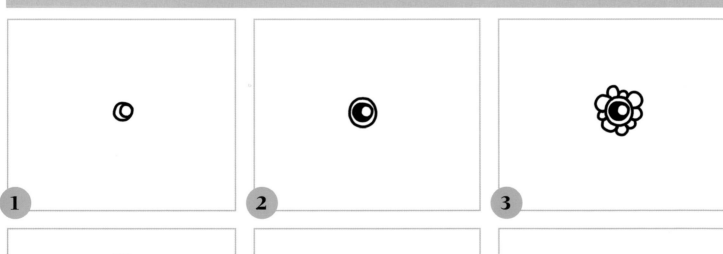

Colored Variation

How to draw Delphinium

1

2

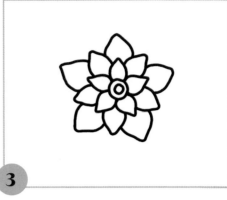

3

4

5

Colored Variation

How to draw Cyclamen

1

2

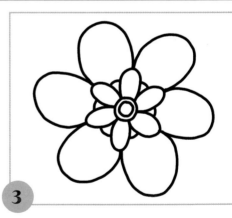

3

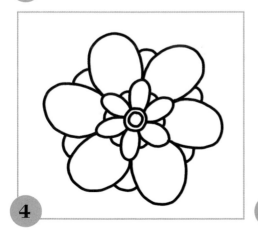

4

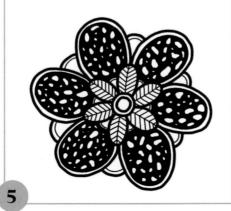

5

Colored Variation

How to draw Holly

1

2

3

4

5

Colored Variation

How to draw Oleander

1

2

3

4

5

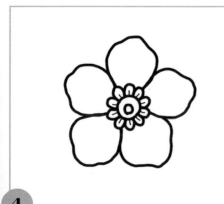

Colored Variation

How to draw Calendula

1

2

3

4

5

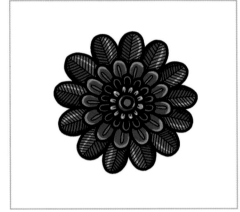

Colored Variation

How to draw Clematis

1

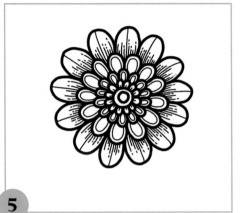

2

3

4

5

Colored Variation

38 Drawing Florals in 5 Easy Steps

How to draw Butterfly Flower

1

2

3

4

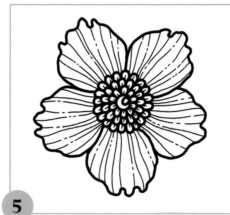

5

Colored Variation

How to draw Hydrangea

1

2

3

4

5

Colored Variation

How to draw Primrose

1

2

3

4

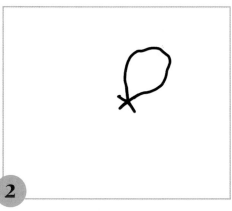

5

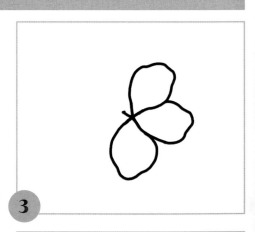

Colored Variation

How to draw Heliotrope

1

2

3

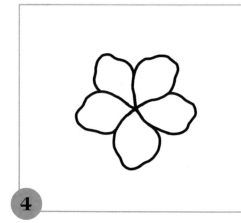

4

5

Colored Variation

How to draw Balloon Flower

1

2

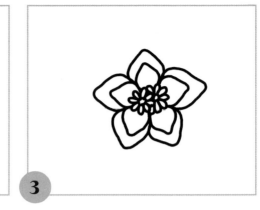

3

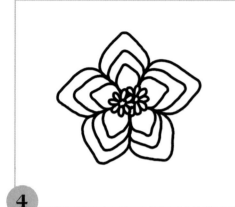

4

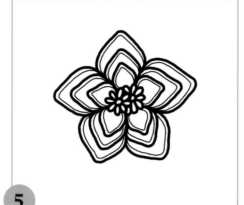

5

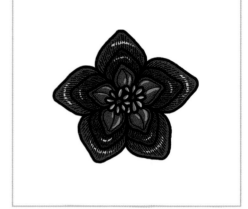

Colored Variation

How to draw Pinwheel Flower

1

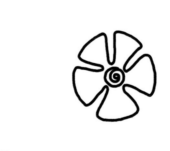

2

3

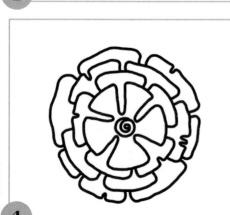

4

5

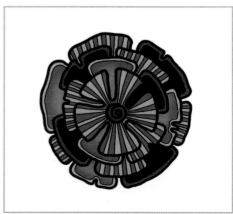

Colored Variation

How to draw Galaxy Flower

1

2

3

4

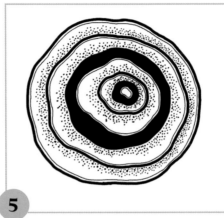

5

Colored Variation

How to draw Euphorbia Flower

1

2

3

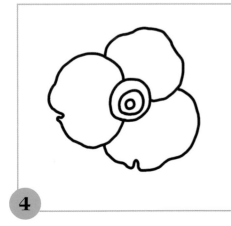

4

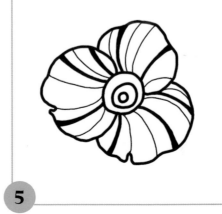

5

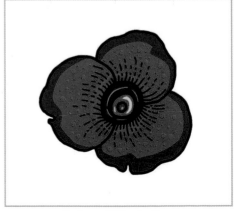

Colored Variation

How to draw Tiger Lily

1

2

3

4

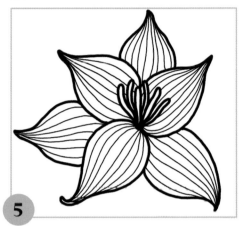

5

Colored Variation

How to draw Star Flower

1

2

3

4

5

Colored Variation

How to draw Sunflower

1

2

3

4

5

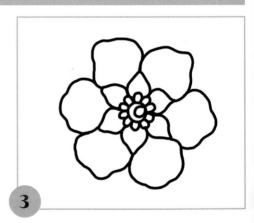

Colored Variation

How to draw Magnolia

1

2

3

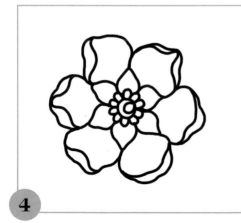

4

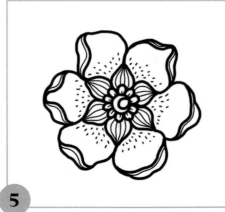

5

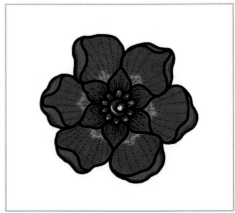

Colored Variation

How to draw Zinnia

1

2

3

4

5

Colored Variation

How to draw Iris

1

2

3

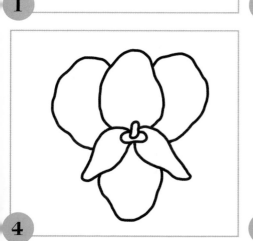

4

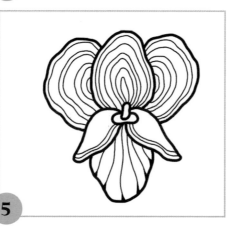

5

Colored Variation

How to draw Wavy Lily

1

2

3

4

5

Colored Variation

How to draw Violet

1

2

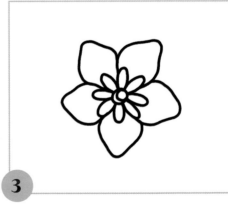

3

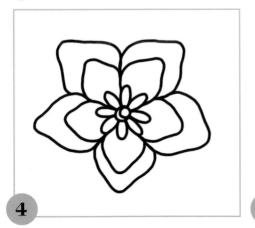

4

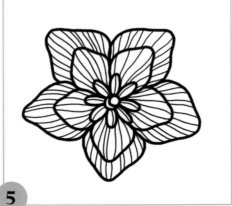

5

Colored Variation

How to draw Periwinkle

1

2

3

4

5

Colored Variation

How to draw Carnation

1

2

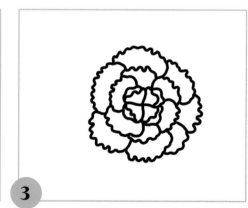

3

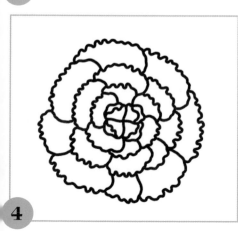

4

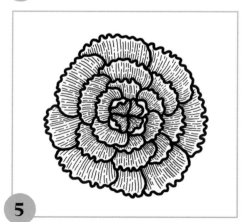

5

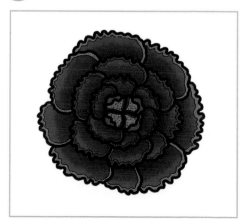

Colored Variation

How to draw Ranunculus

1

2

3

4

5

Colored Variation

How to draw Windflower

1

2

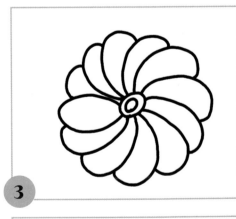

3

4

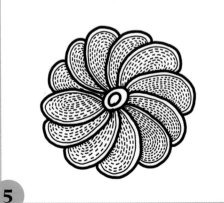

5

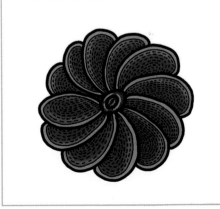

Colored Variation

How to draw Gardenia

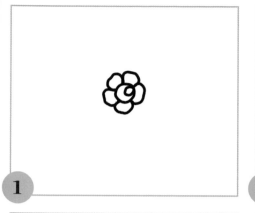

1

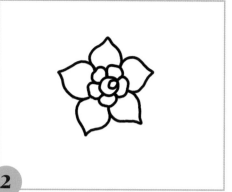

2

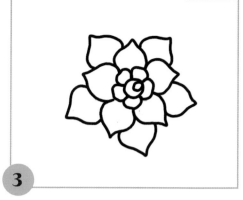

3

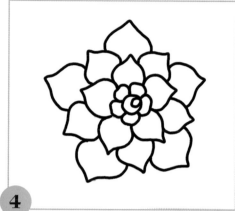

4

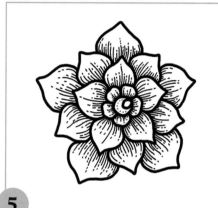

5

Colored Variation

How to draw Pebble Flower

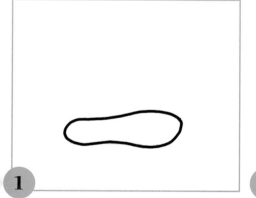

1

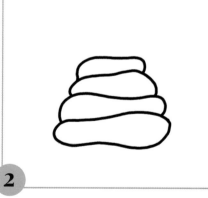

2

3

4

5

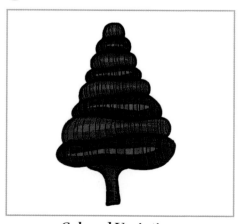

Colored Variation

How to draw Daisy

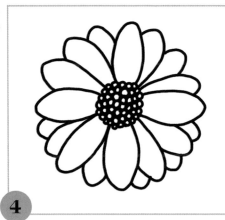

1

2

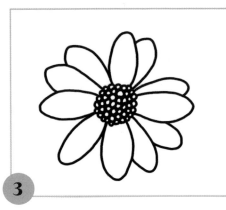

3

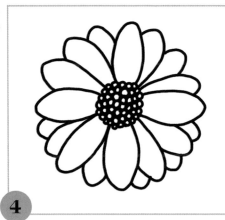

4

5

Colored Variation

How to draw Lantana

1

2

3

4

5

Colored Variation

How to draw Ruffled Flower

1

2

3

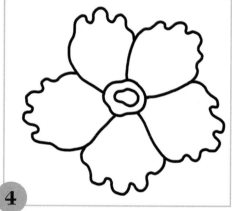

4

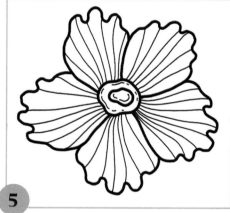

5

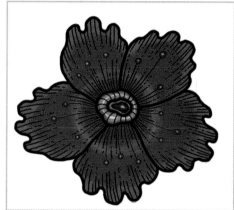

Colored Variation

How to draw Hollyhock

1

2

3

4

5

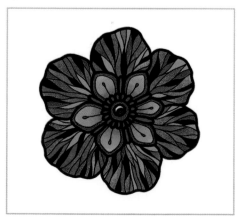

Colored Variation

How to draw Amaryllis

1

2

3

4

5

Colored Variation

How to draw Anthurium

1

2

3

4

5

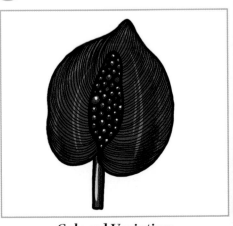

Colored Variation

How to draw Coral Flower

1

2

3

4

5

Colored Variation

How to draw Fan Flower

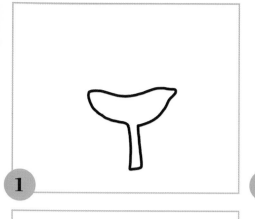

1

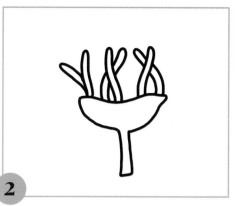

2

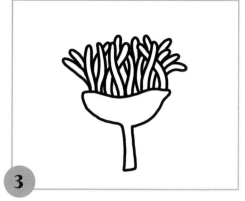

3

4

5

Colored Variation

How to draw Clover

1

2

3

4

5

Colored Variation

How to draw Striped Flower

1

2

3

4

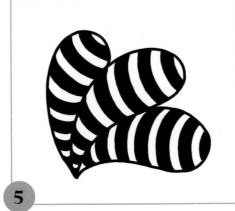
5

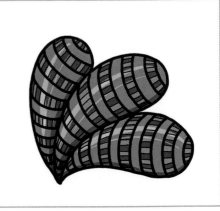
Colored Variation

How to draw Bird of Paradise

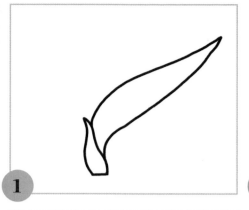

1

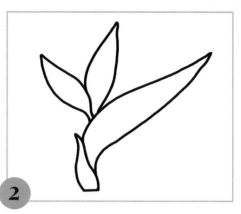

2

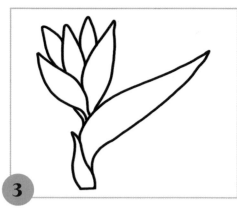

3

4

5

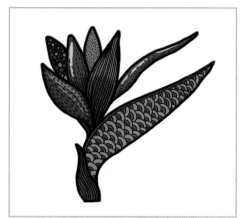

Colored Variation

How to draw Calla Lily

1

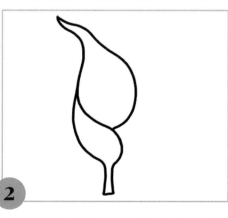

2

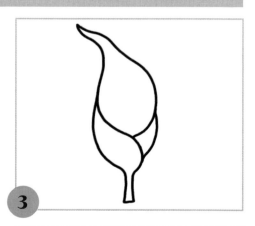

3

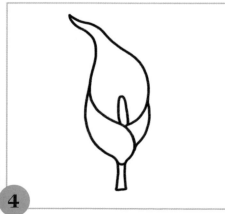

4

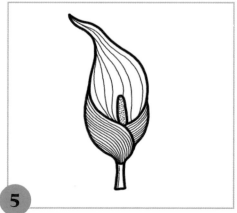

5

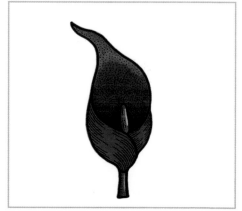

Colored Variation

How to draw Fuchsia

1

2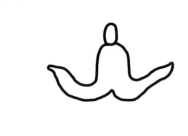

3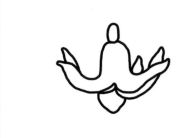

4

5

Colored Variation

How to draw Lotus

1

2

3

4

5

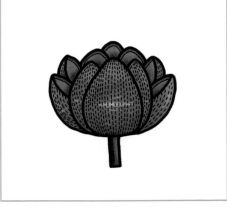

Colored Variation

How to draw Cup Flower

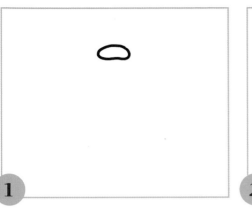
1

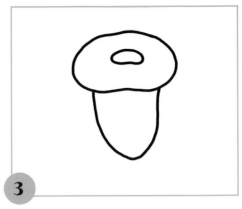
2

3

4

5

Colored Variation

How to draw Lupine

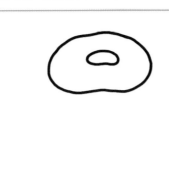
1

2

3

4

5

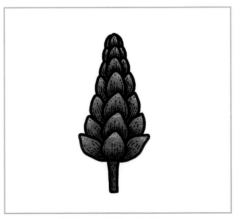

Colored Variation

How to draw Tulip

1

2

3

4

5

Colored Variation

How to draw Pitcher Plant

1

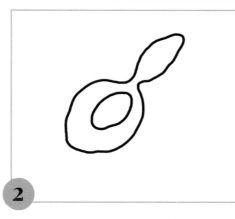
2

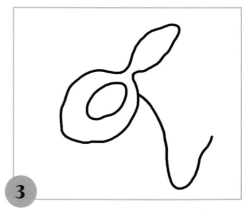
3

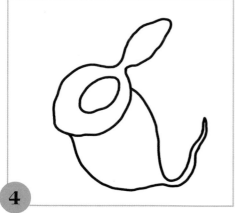
4

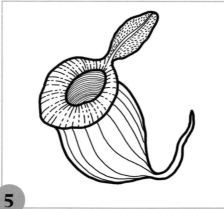
5

Colored Variation

How to draw Wheat Flower

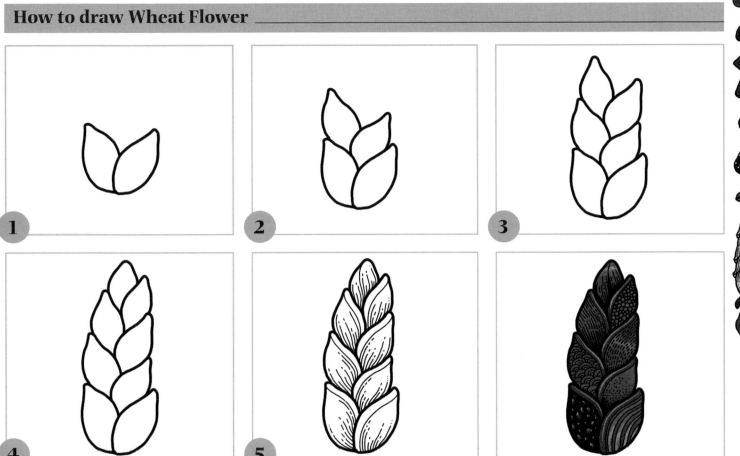

1

2

3

4

5

Colored Variation

Leaves
Step by Step

How to draw Monstera Leaf

1

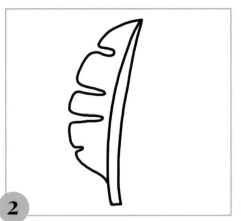

2

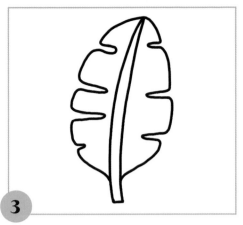

3

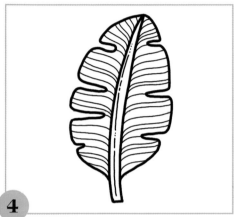

4

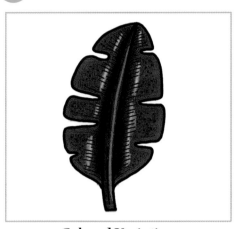

Colored Variation

How to draw Chestnut Leaf

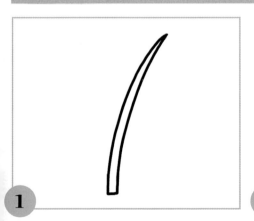

1

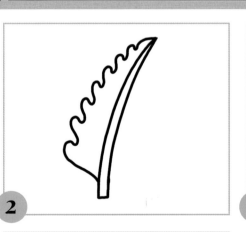

2

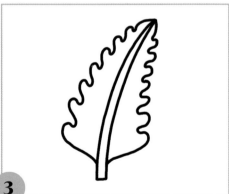

3

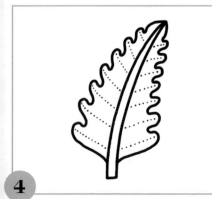

4

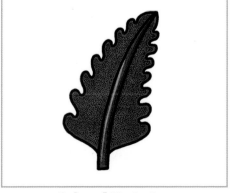

Colored Variation

How to draw Alder Leaf

1

2

3

4

Colored Variation

How to draw Banana Leaf

1

2

3

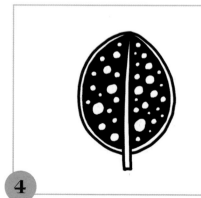

4

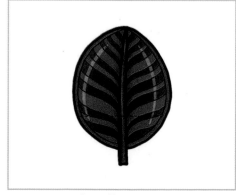

Colored Variation

How to draw Crab Apple Leaf

1

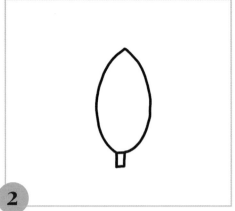

2

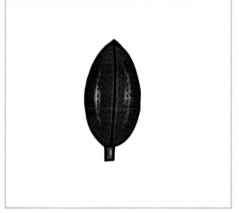

3

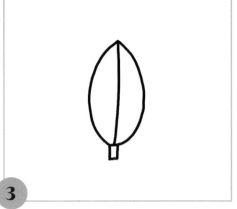

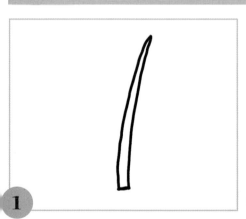

4

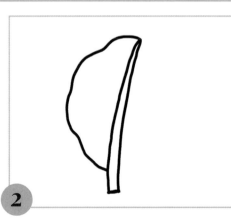

Colored Variation

How to draw Beech Leaf

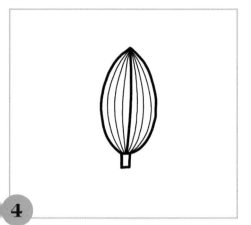

1

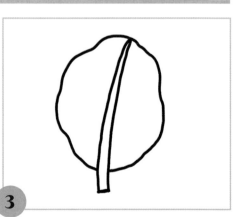

2

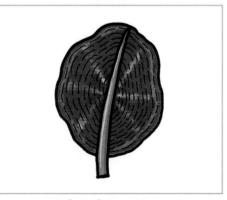...

3

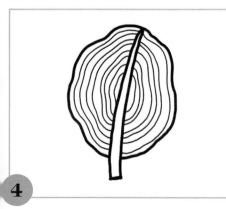

4

Colored Variation

How to draw Smoketree Leaf

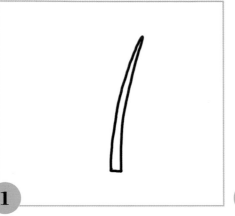

1

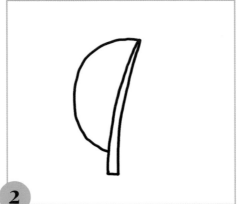

2

3

4

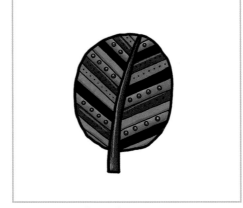

Colored Variation

How to draw Fiddlehead Leaf

1

2

3

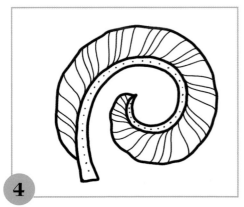

4

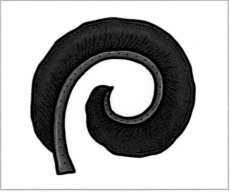

Colored Variation

How to draw Hornbeam Leaf

1

2

3

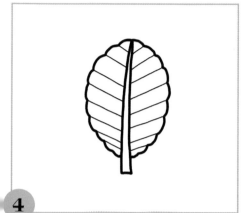

4

Colored Variation

How to draw Holly Leaf

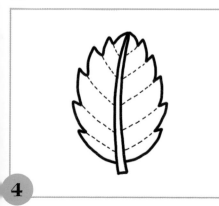

1

2

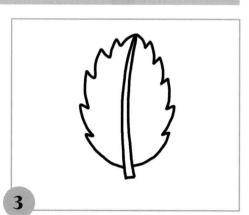

3

4

Colored Variation

How to draw Fern Leaf

1

2

3

4

Colored Variation

How to draw Heart Palm Leaf

1

2

3

4

Colored Variation

66 Drawing Florals in 5 Easy Steps

How to draw Laurel Leaf

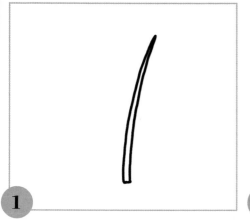

1

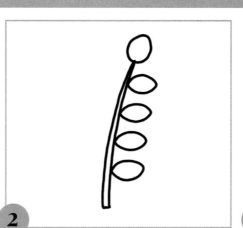

2

3

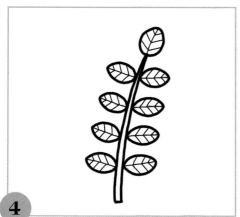

4

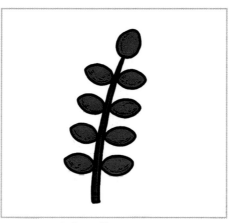

Colored Variation

How to draw Elm Leaf

1

2

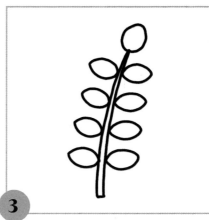

3

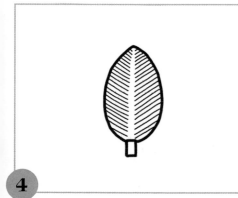

4

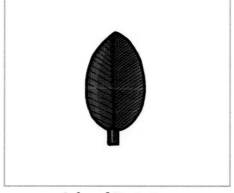

Colored Variation

How to draw Philodendron Leaf

1

2

3

4

Colored Variation

How to draw Maple Leaf

1

2

3

4

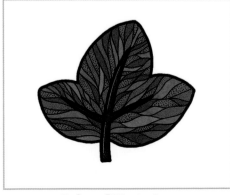

Colored Variation

How to draw Olive Leaf

1

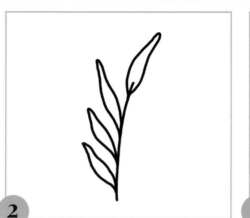

2

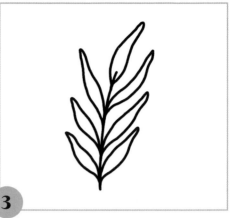

3

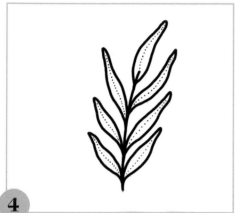

4

Colored Variation

How to draw Snake Leaf

1

2

3

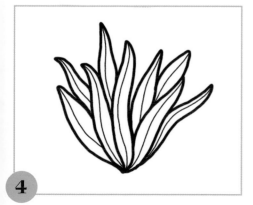

4

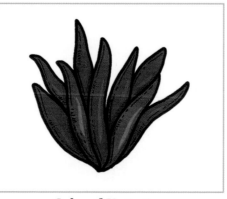

Colored Variation

How to draw Jacaranda Leaf

1

2

3

4

Colored Variation

How to draw Rounded Palm Leaf

1

2

3

4

Colored Variation

How to draw Peperomia Leaf

1

2

3

4

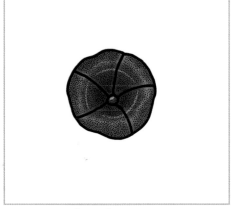

Colored Variation

Doodle
Elements
Step by Step

How to draw Layered Points

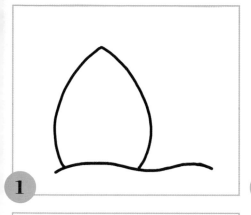

1

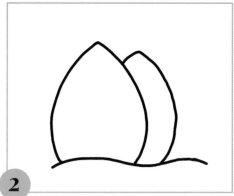

2

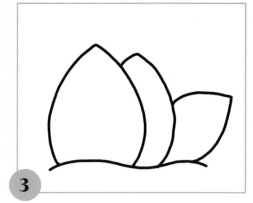

3

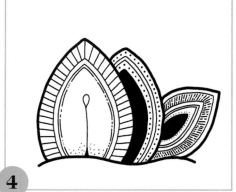

4

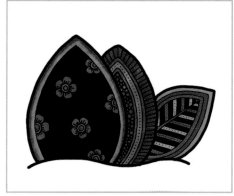

Colored Variation

How to draw Coral Reef

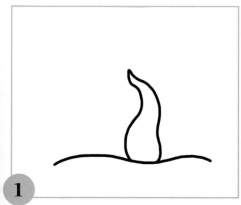

1

2

3

4

Colored Variation

How to draw Sea Snakes

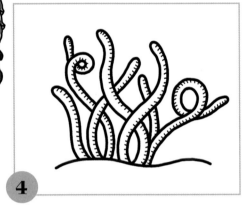

1

2

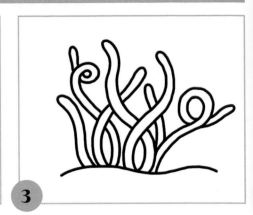

3

4

Colored Variation

How to draw Round Shells

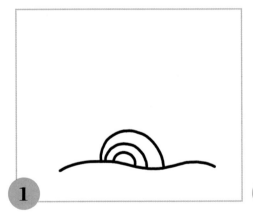

1

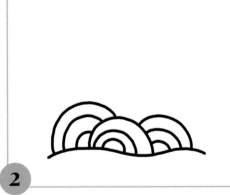

2

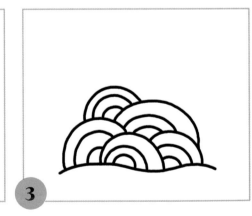

3

4

Colored Variation

How to draw Mushrooms

1

2

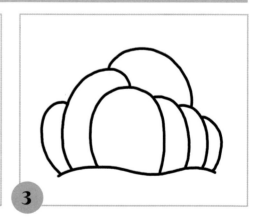

3

4

Colored Variation

How to draw Layered Curves

1

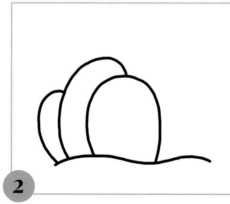

2

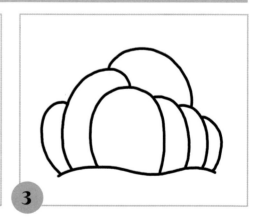

3

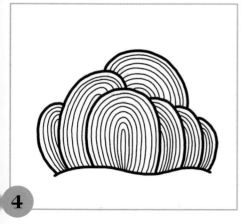

4

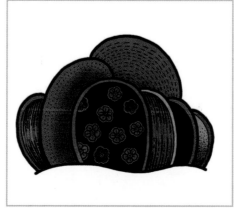

Colored Variation

How to draw Flowing Flame

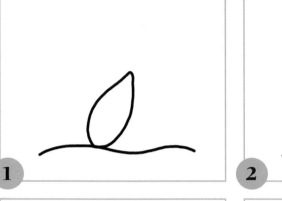

1

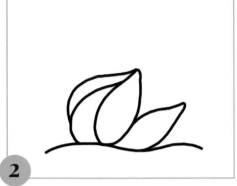

2

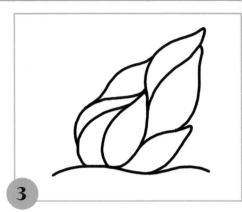

3

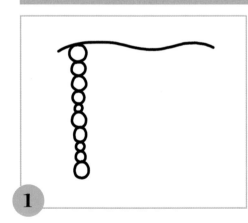

4

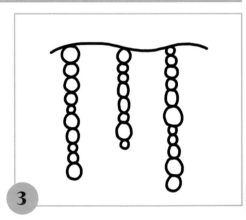

Colored Variation

How to draw Beaded Curtain

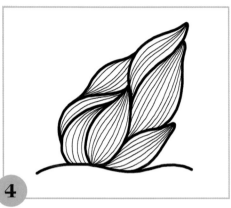

1

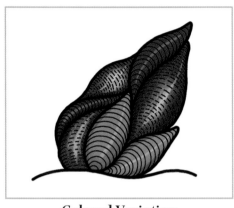

2

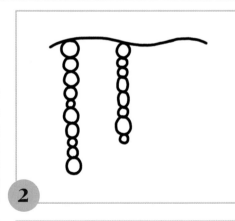

3

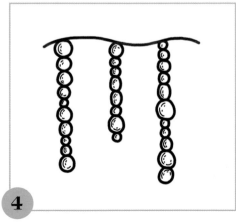

4

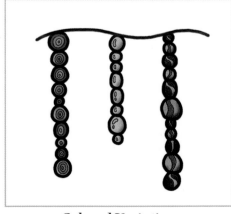

Colored Variation

How to draw Lichen Layers

1

2

3

4

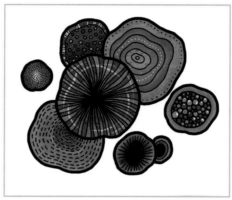

Colored Variation

How to draw Bubble Pile

1

2

3

4

Colored Variation

Composing a Blossoming Creation

This is my favorite doodling style, combining all the small and big flowers together to create a big, lush, and blossoming creation. I also refer to this as "clustered technique" where you work by clustering your elements together to create a big and tightly arranged result.

1. Roughly sketch with pencil where you want to put your flowers. Scatter them here and there. Overlap them, with some in front and some behind the others. You may want to mix between big and medium flowers, too.

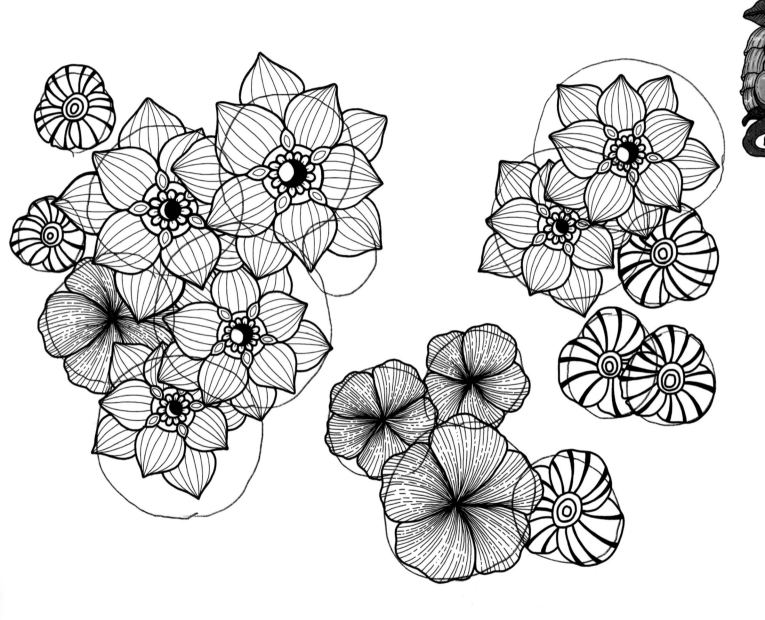

2. Now you can start drawing your flowers. Put some leaves in between if you want. Remember to draw some flowers big and some flowers small, even if they are of the same kind, to make your composition more natural.

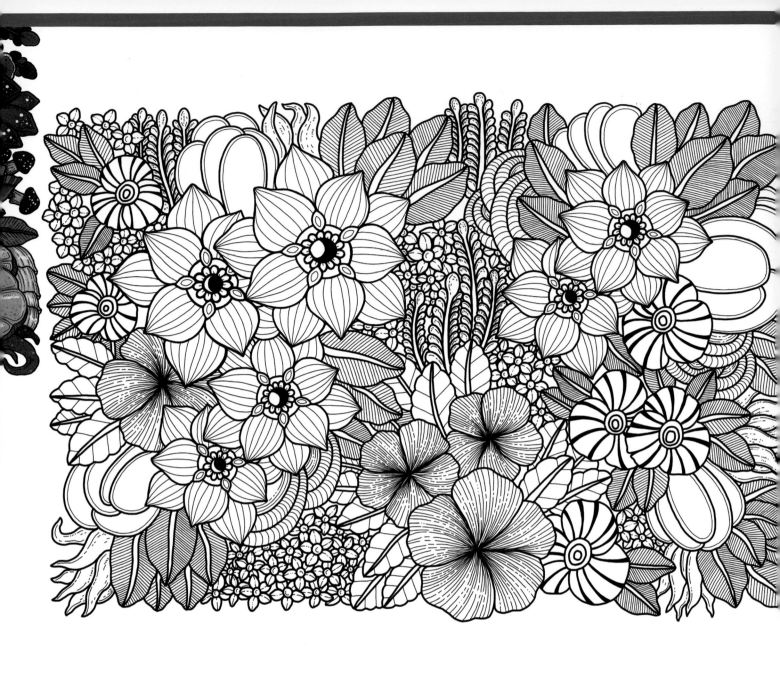

3. When you are done with the flowers, it is time to fill up the empty spaces. Start drawing different kinds of leaves around your flowers. Make sure to overlap them, too. Next, add more elements, such as tendrils, vines, and doodle elements. You can also put some small flowers and more leaves to balance out the whole composition, if necessary. Erase your pencil guidelines.

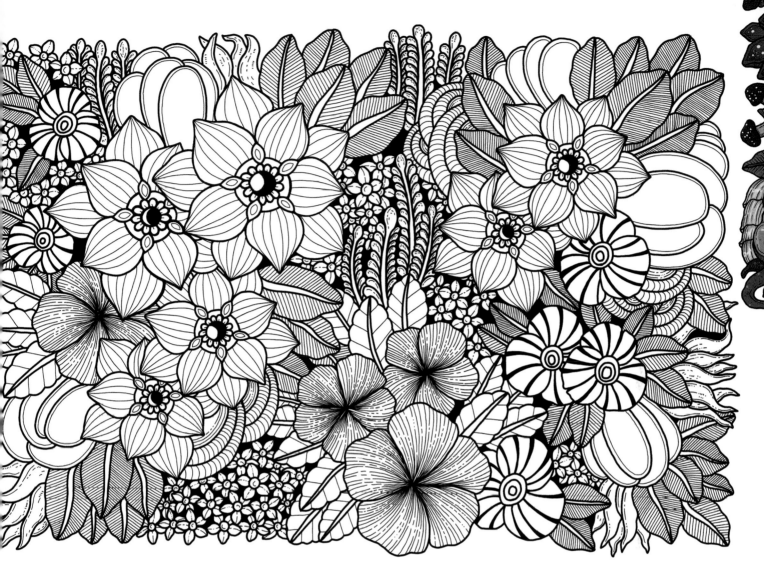

4. Lastly, if you are like me, you may want to fill all the small gaps with black. The black background can make your drawings stand out even more. This is optional, though!

Check out some of these ideas on how to combine your elements.

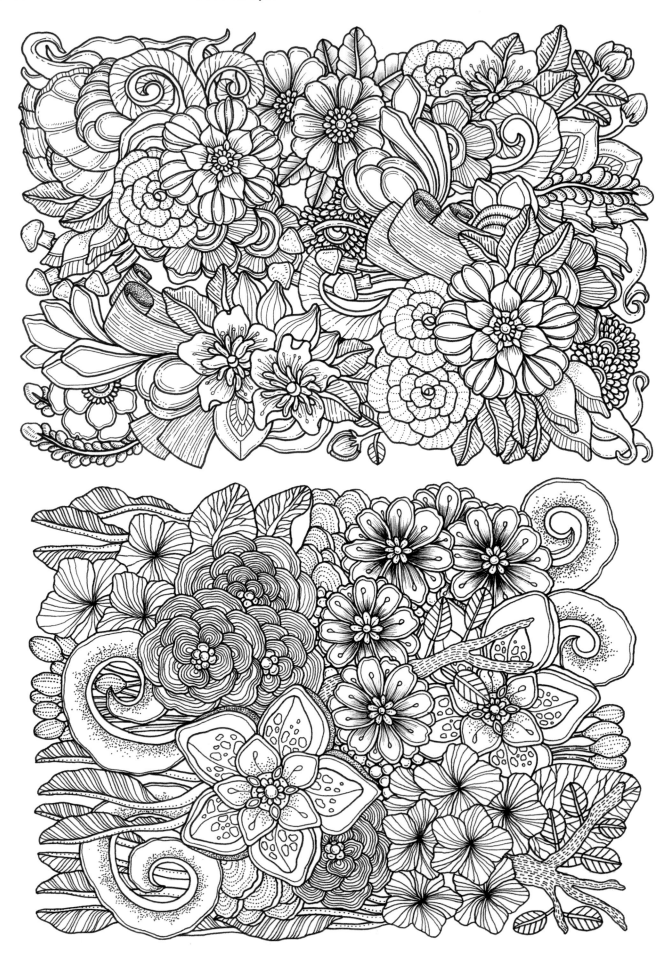

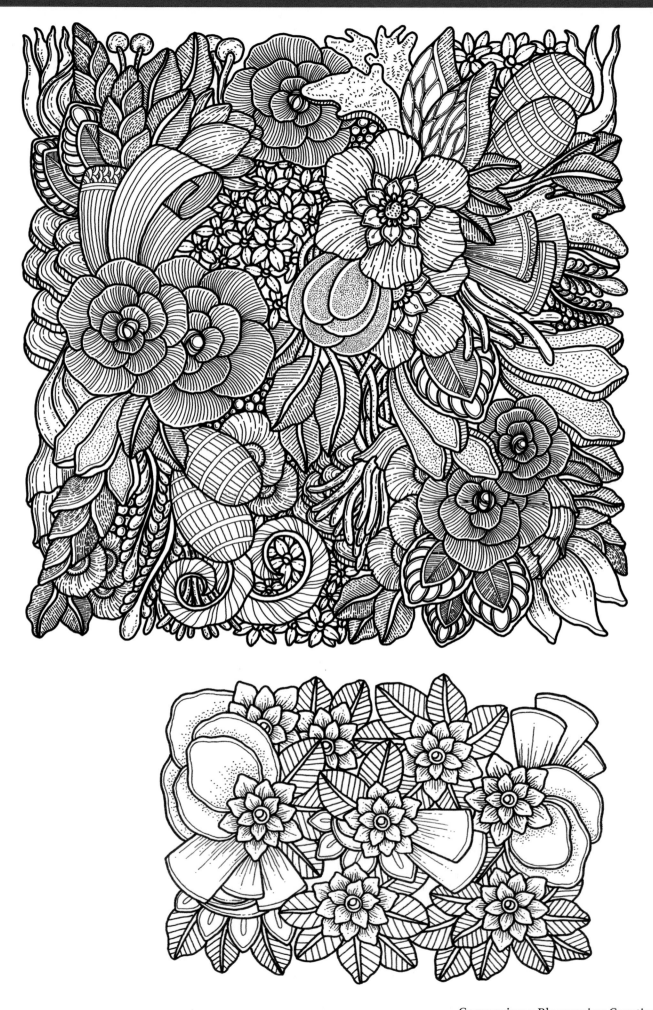

Ideas for Creating Floral Designs

Repetitive

Repetition is probably the easiest thing to do, as you only need one flower type, but it does involve a time commitment. Still, the finished work will be amazing! To use this approach, you only need to draw one flower, then repeat and overlap the same flower until you fill up the entire sheet of paper or working surface. Vary between regular-size flowers and small flowers for an impressive effect!

Alphabets/Text

You can create unique alphabets, text, or quotes by adding various floral elements to them. First, sketch your alphabet or text. Then, draw your florals around it. You can use flowers as decoration around your alphabet, use them as patterns inside your alphabet, or simply draw your flowers to assume the shape of the letters.

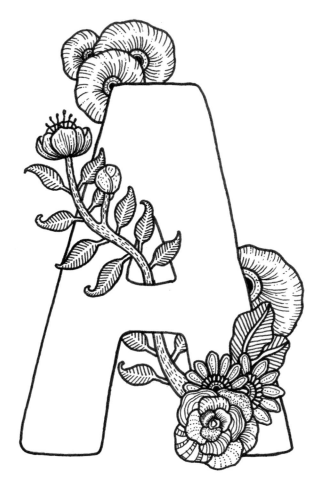

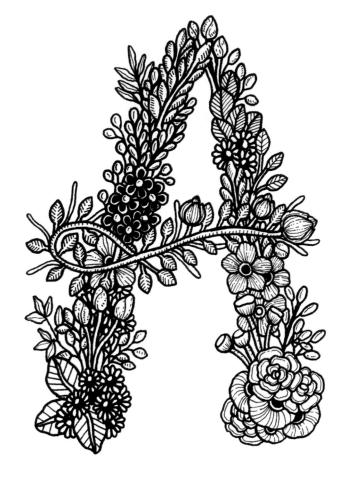

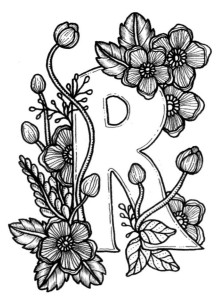

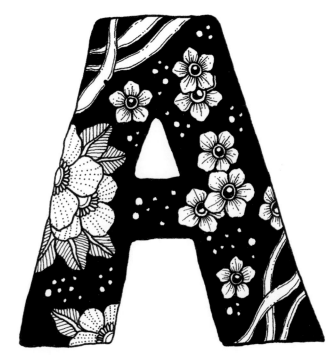

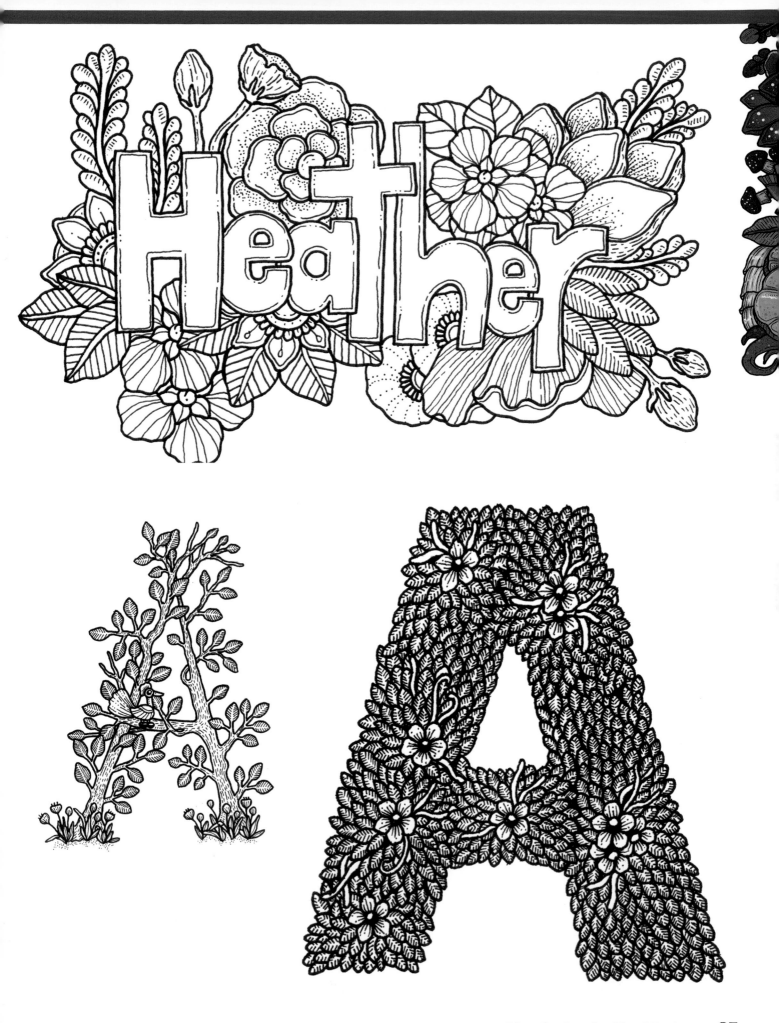

Layered

Layering is very easy. Layer your flowers and elements by stacking them together on top of each other. Repeat until you fill up the paper. Use different flowers and elements for each layer.

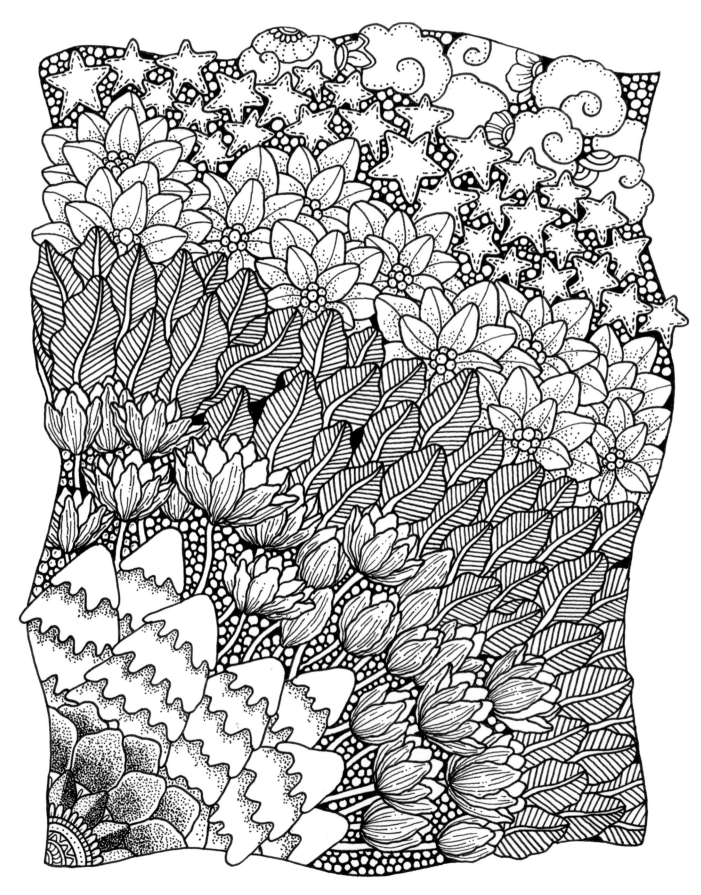

Bouquet

To use this style, first draw the rough shape of a bouquet. Next, mix and match your flowers to create a bouquet of floral creations. Use a variety of flowers and different sizes, too!

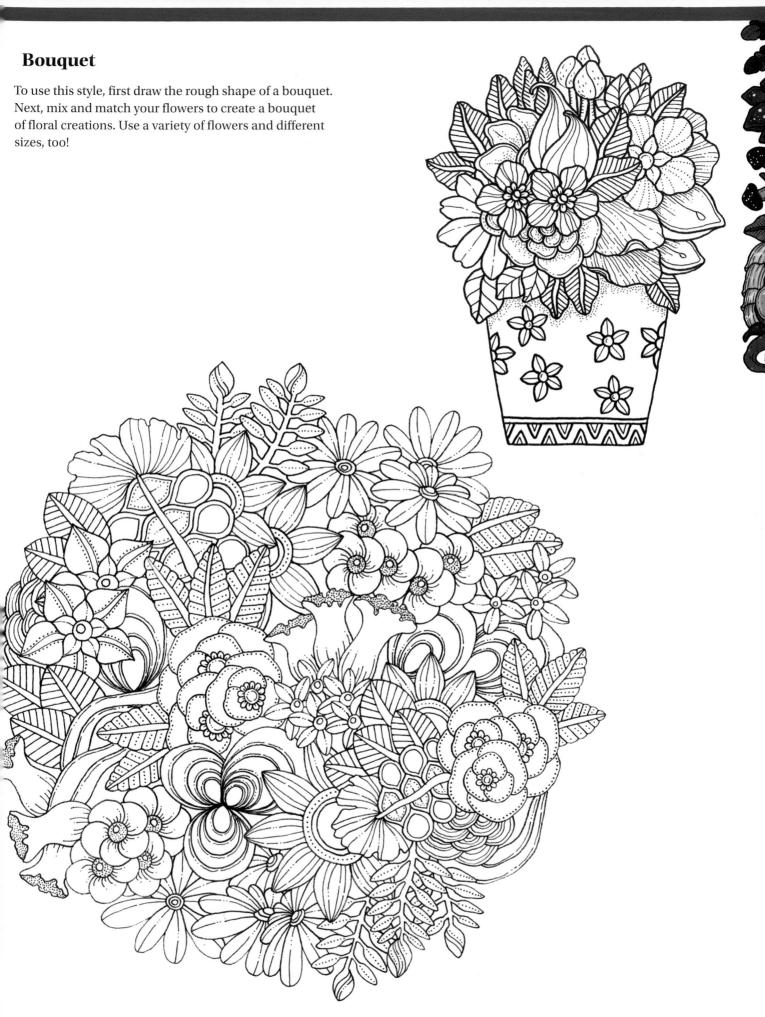

Frame/Border

A floral frame or border is much more interesting than a boring circle or line. You can create a frame or border by combining all your floral elements together to form the shape of your desired frame or border. To do this, first draw the rough shape of your frame or border. It can be round, square, triangular, or any shape you like. Next, start adding your flowers and elements in and around the shape. Try creating both intricate and simple drawings.

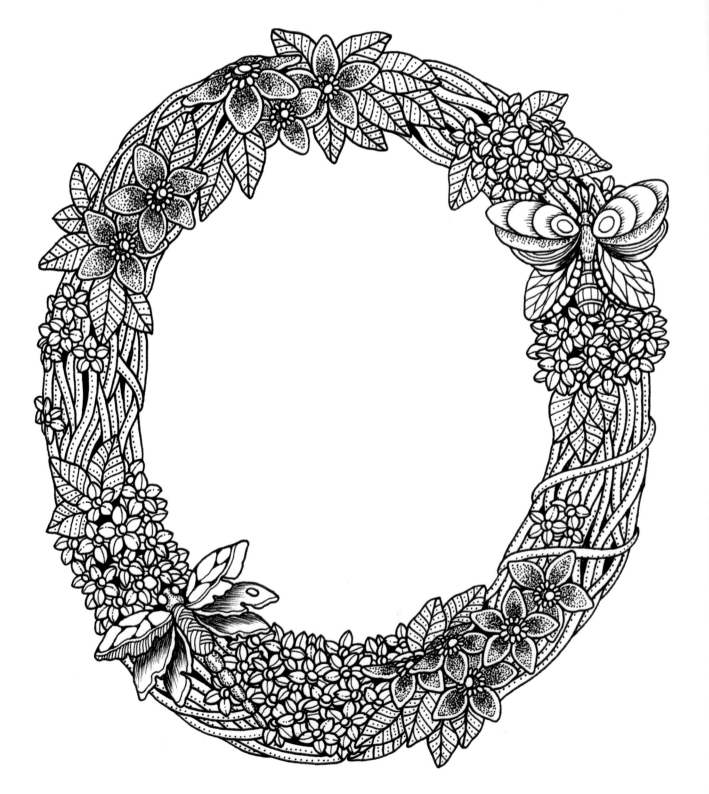

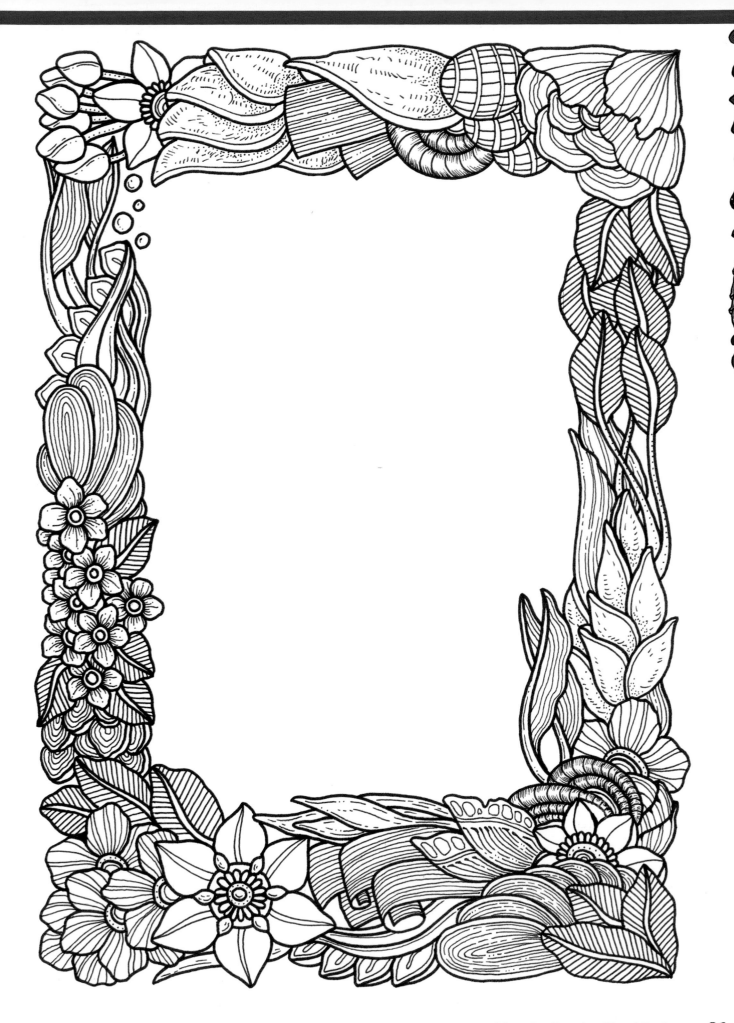

Shapes

This is a fun idea that works beautifully with floral art. Draw a shape and embellish it with your favorite flowers and elements. To work with shapes, you can either fill your shape within the defined lines or you can draw your florals to assume the shape.

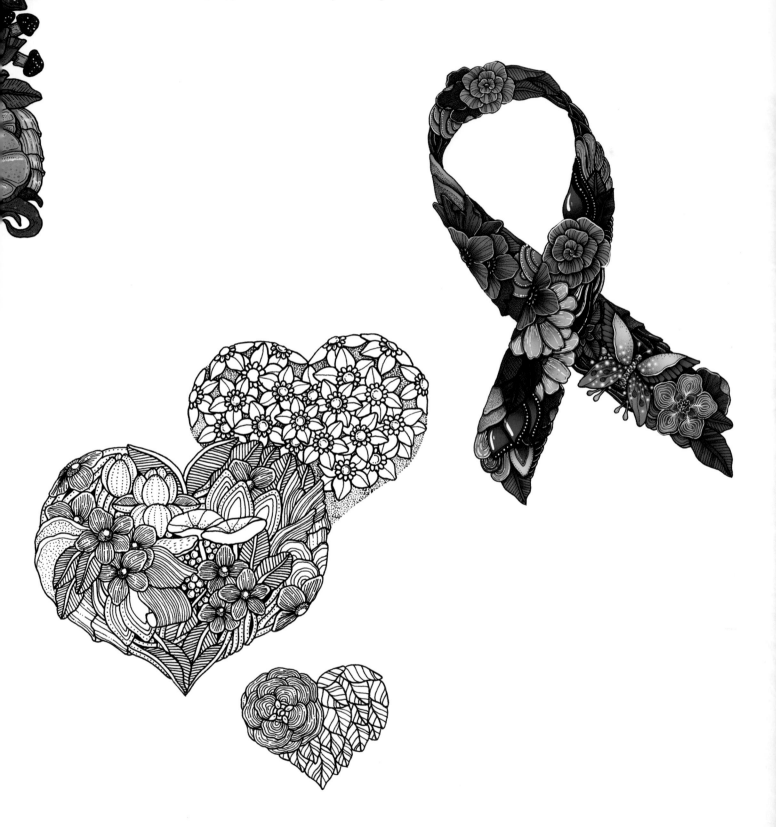

Loose and Separated

A simple, clean, and elegant creation can be just as pretty and interesting as something more elaborate. Sometimes, you do not need to keep your flowers tightly together all the time. Draw your flowers randomly by spacing them out and keeping them separated. Pay attention to your details where you want to draw attention, since you are using fewer elements for this style.

About the Author

My name is Marty, and I have been drawing and doodling for many years. I love to draw floral art and animals, whether real or from my imagination. They are my favorite subjects to draw. I have always incorporated them in my work. Playing with lines, intricate details, endless layers, and playful patterns absolutely makes me happy, and, perhaps, a bit obsessed!

Professionally, I've taken part in international art exhibitions, published several adult coloring books, and run art workshops where I teach drawing floral art. As an artist,

doodler, and adult coloring book author, I was voted the 2016 Top Doodler in Malaysia by Tally Press. I was selected as one of the 250 artists from all over Asia for Asia Illustrators (2019), and I am a Floral Doodle Workshop Instructor, a TikTok Art Influencer, and an official Faber-Castell art workshop instructor. My work has been featured in newspapers and magazines around the world, and I've collaborated with dozens of companies, including Disney Malaysia, Faber-Castell, Nespresso, TikTok, TIME Internet, Shell, and WWF.

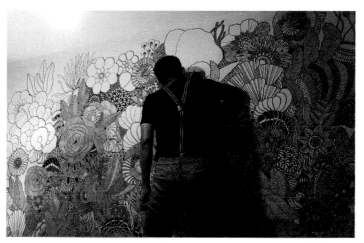

Here I am at work on a mural. Floral art can be very large.

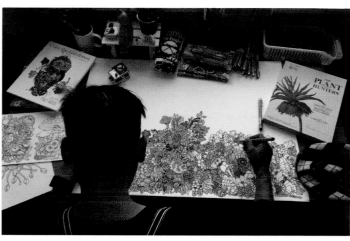

Floral art can also be very small. Here I am drawing a smaller piece of floral art.

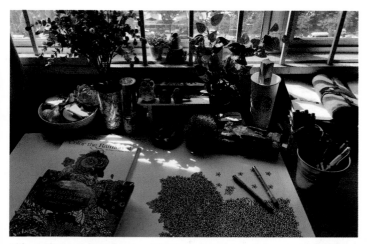

I like to bring a lot of natural light and greenery into my workspace.

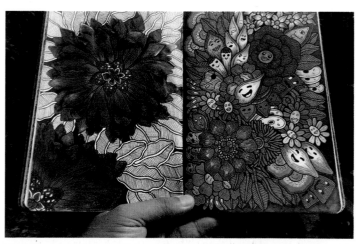

Here's a colorful look inside one of my sketchbooks.

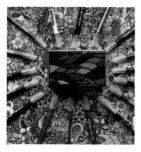
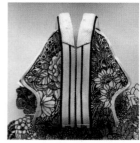

My floral art has been featured in exhibitions and collaborations around the world.

Index